Whimsically Zany Zen Color Me Book 3

To All who've stood by me through years of surprises... Thank you!

Copyright © 2017 Scott Monet

All rights reserved.

ISBN: 1539441946
ISBN-13: 978-1539441946

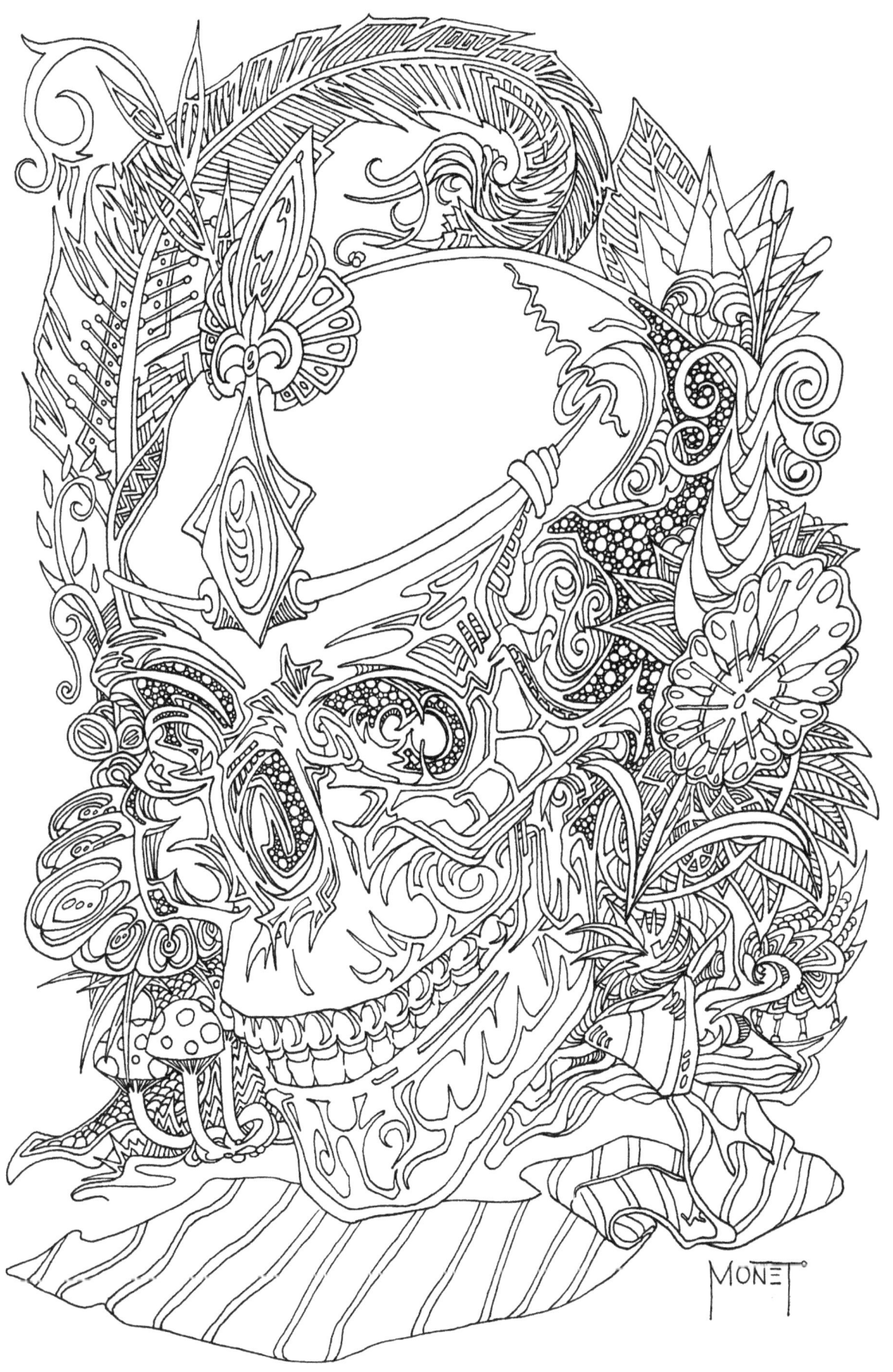

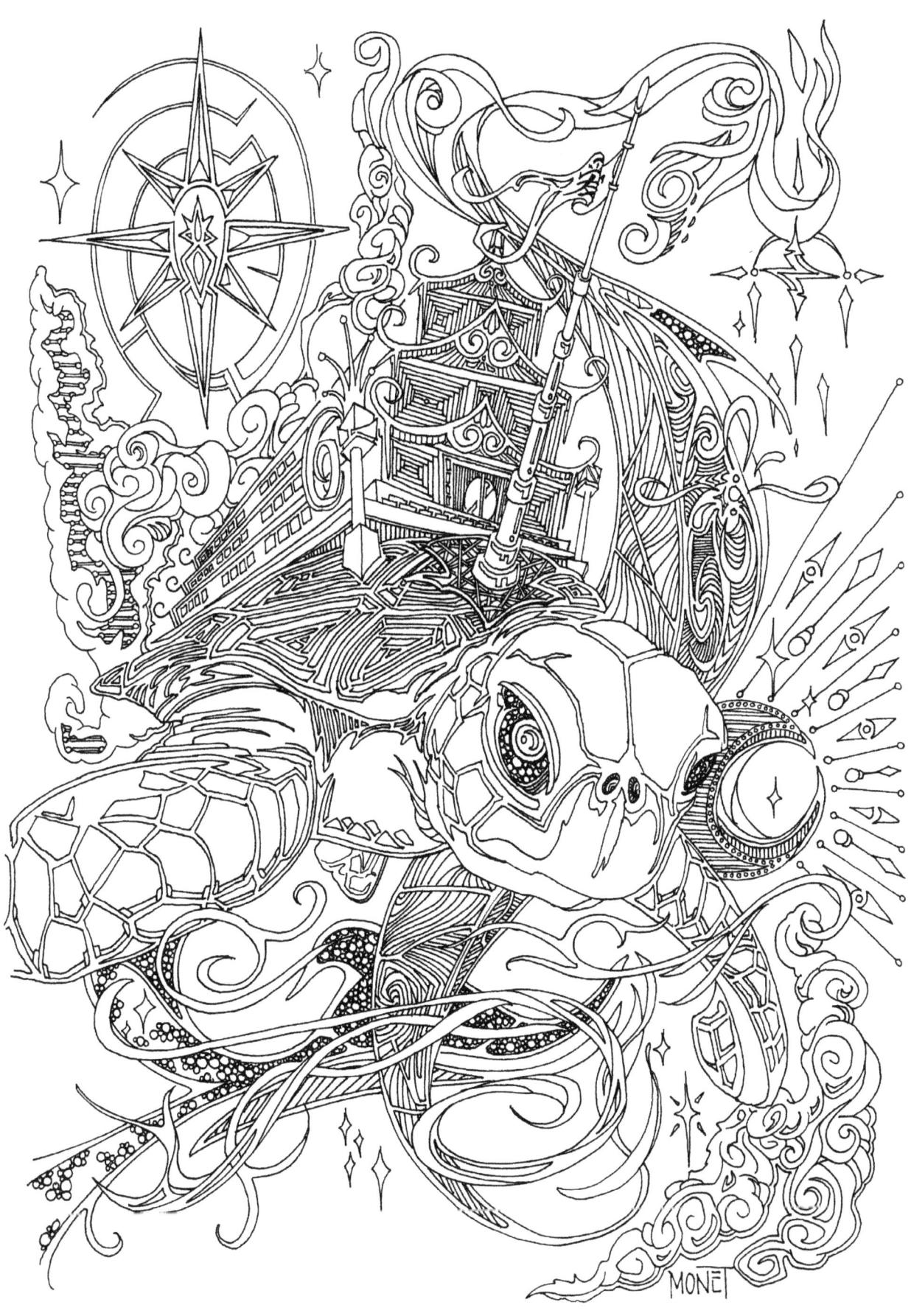

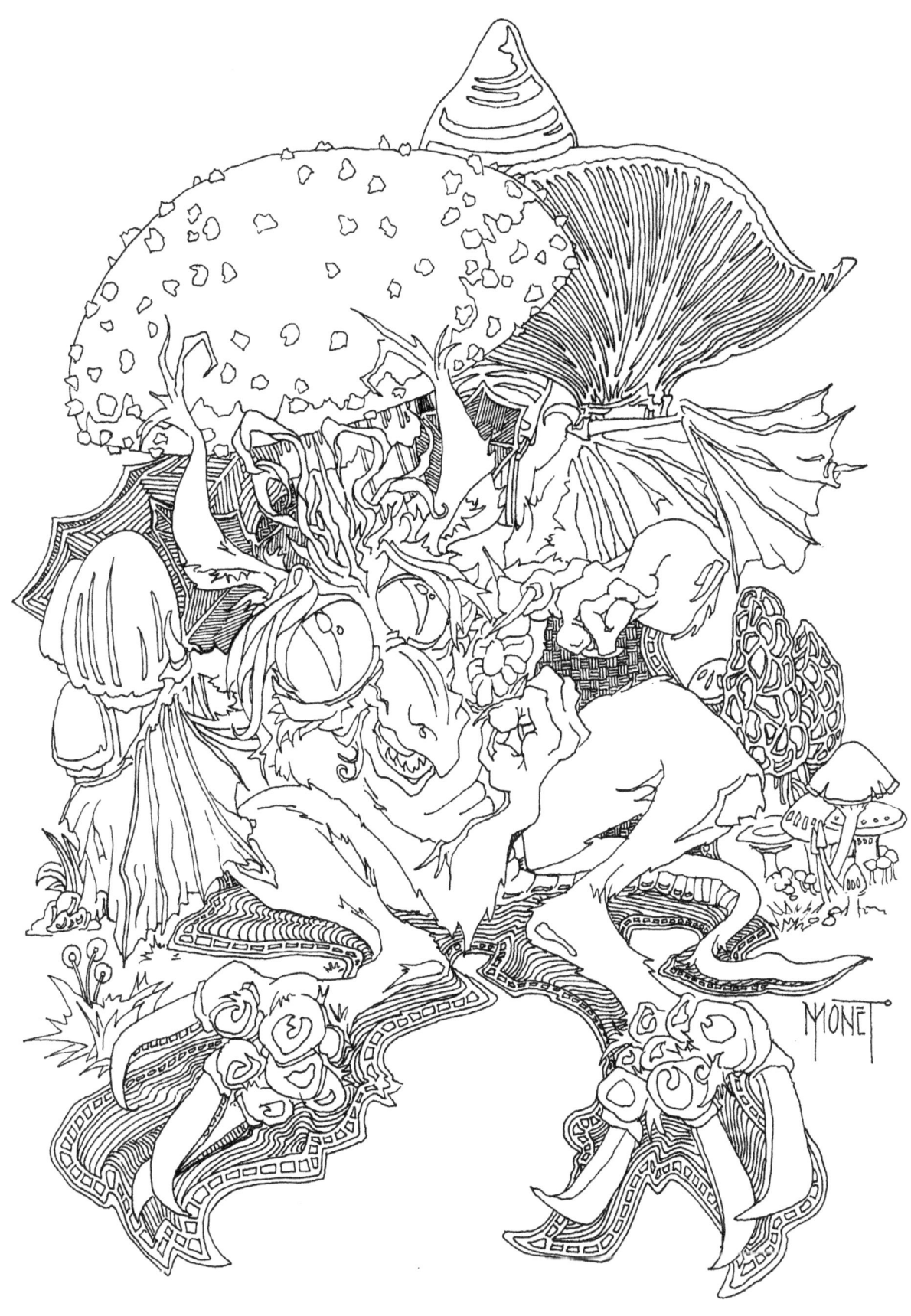

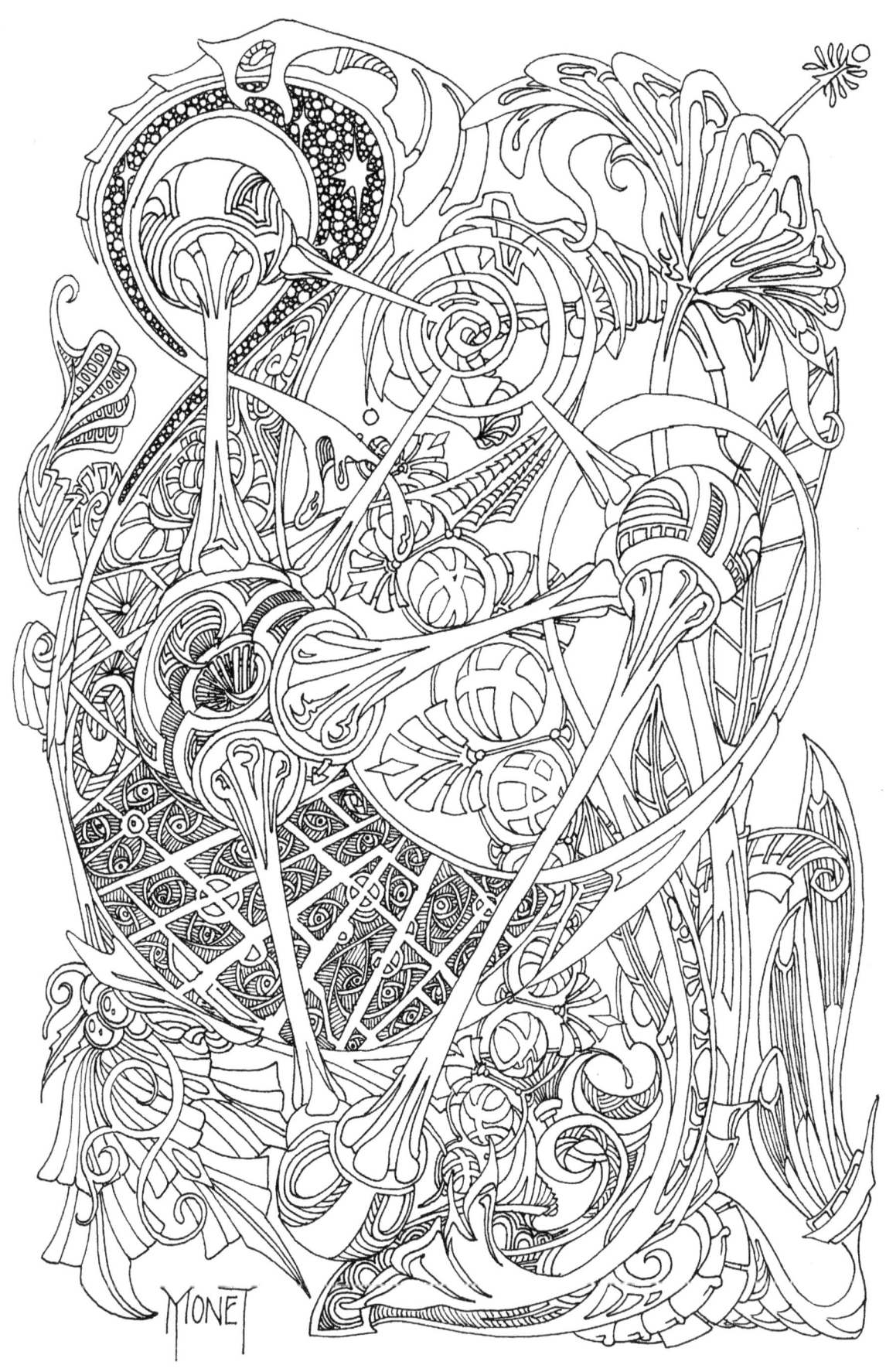

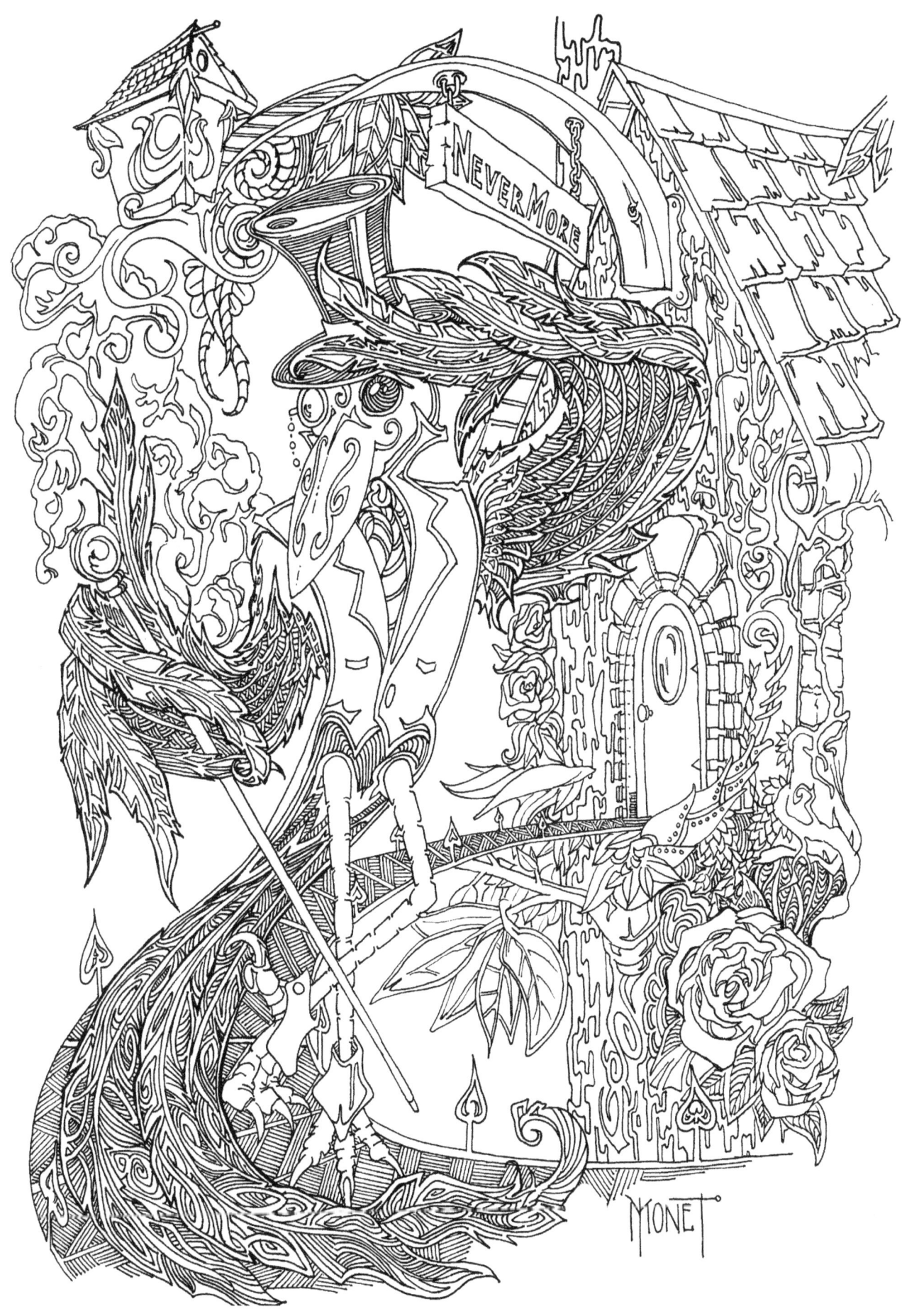

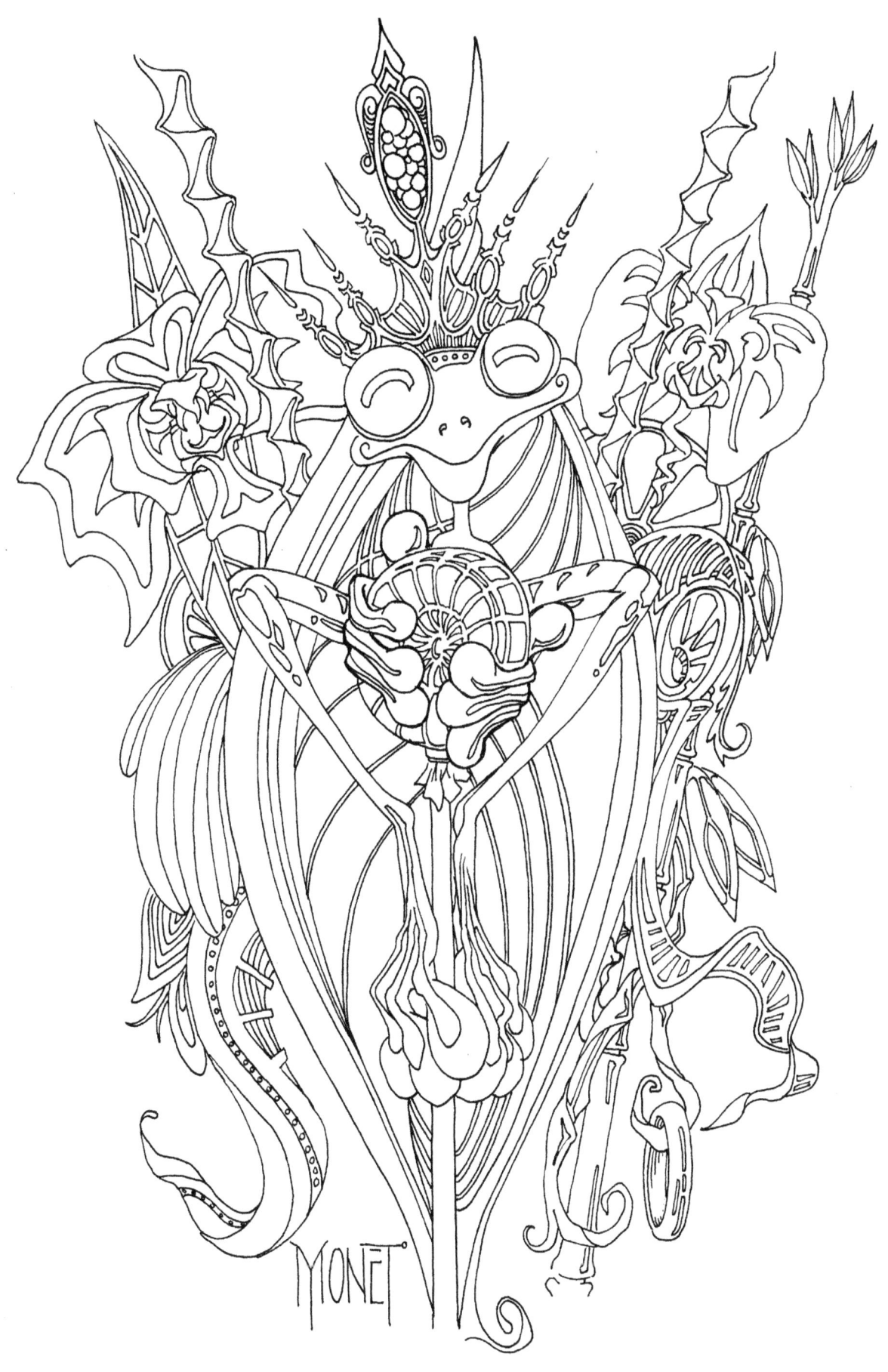

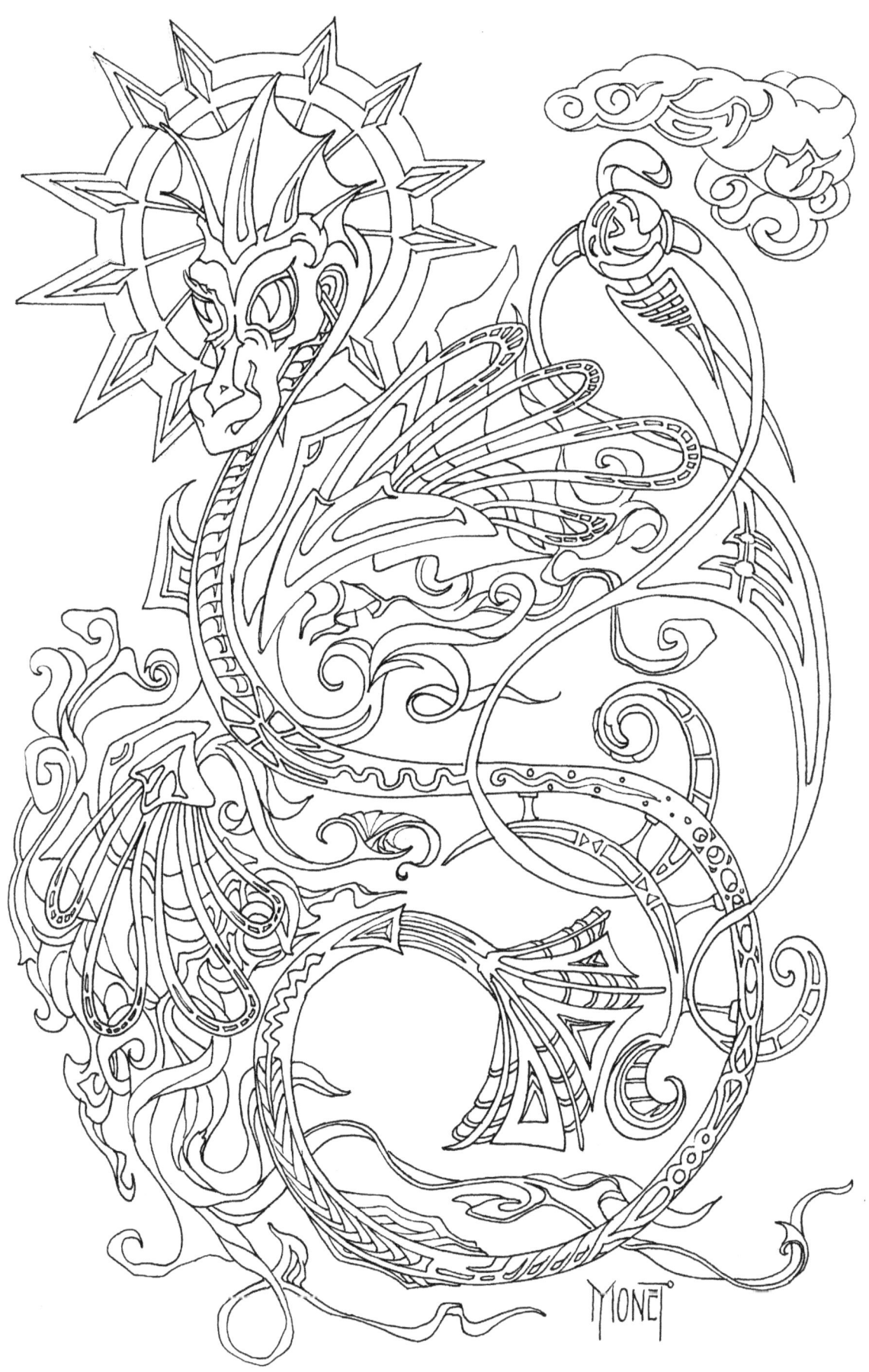

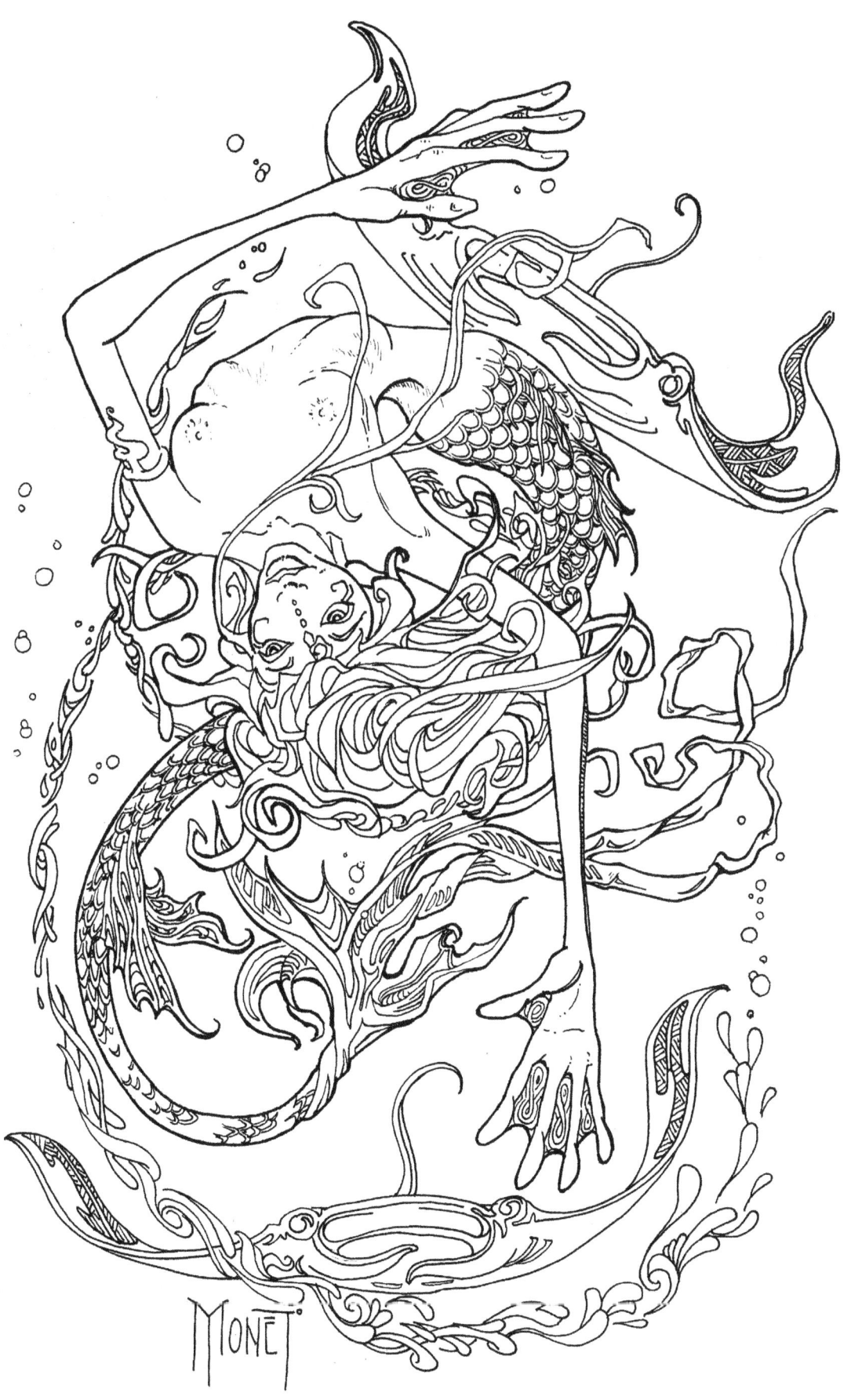

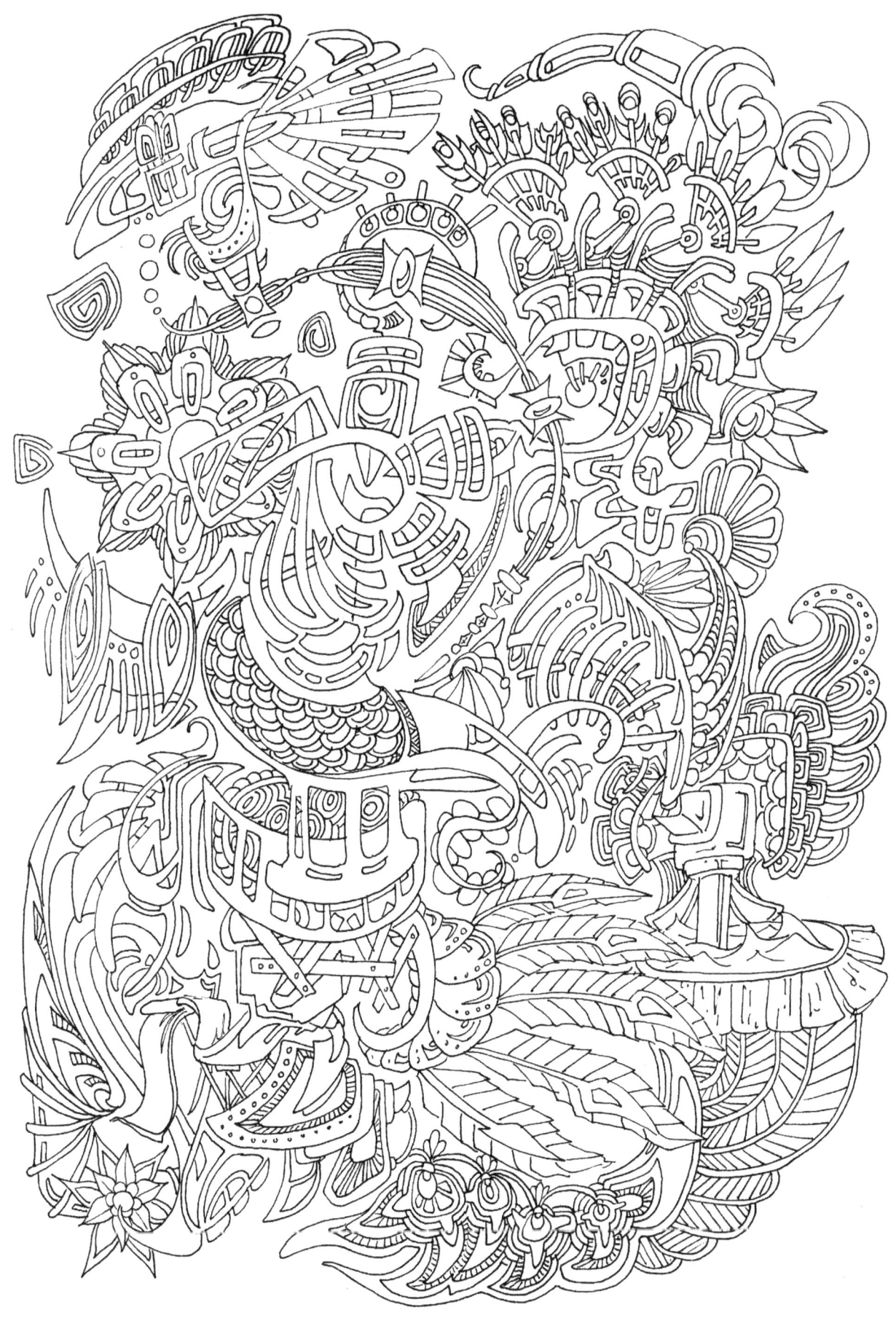

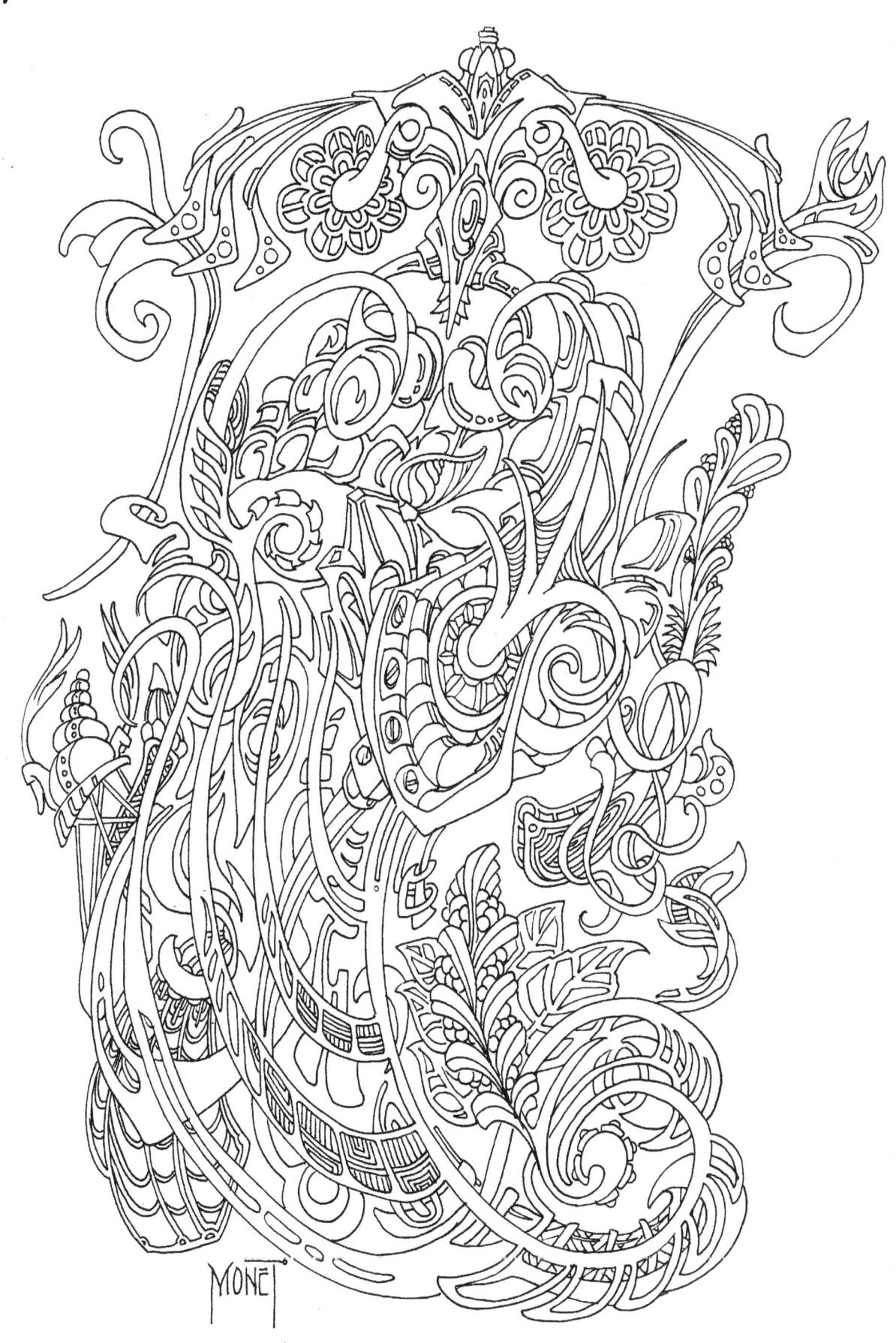

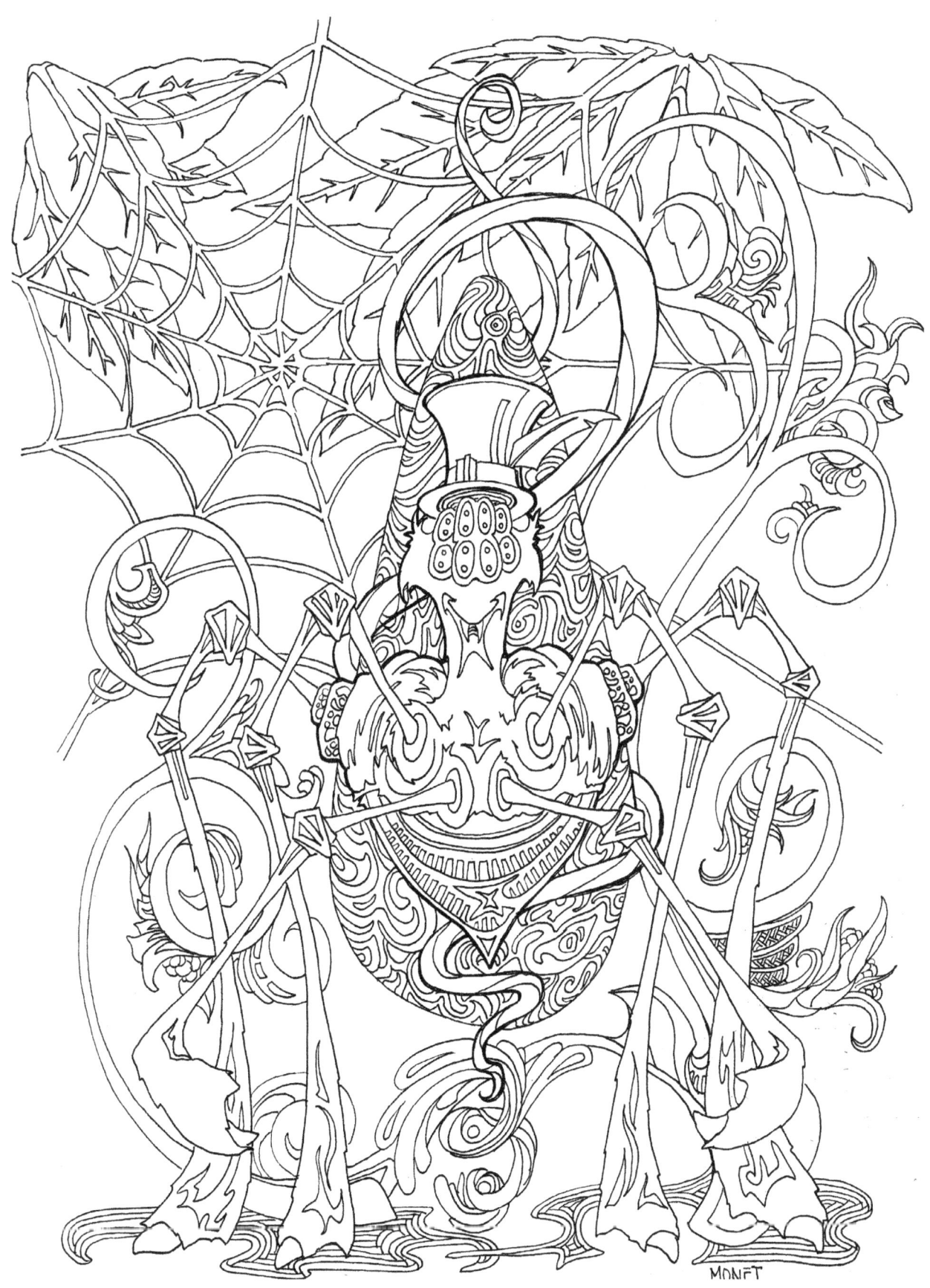

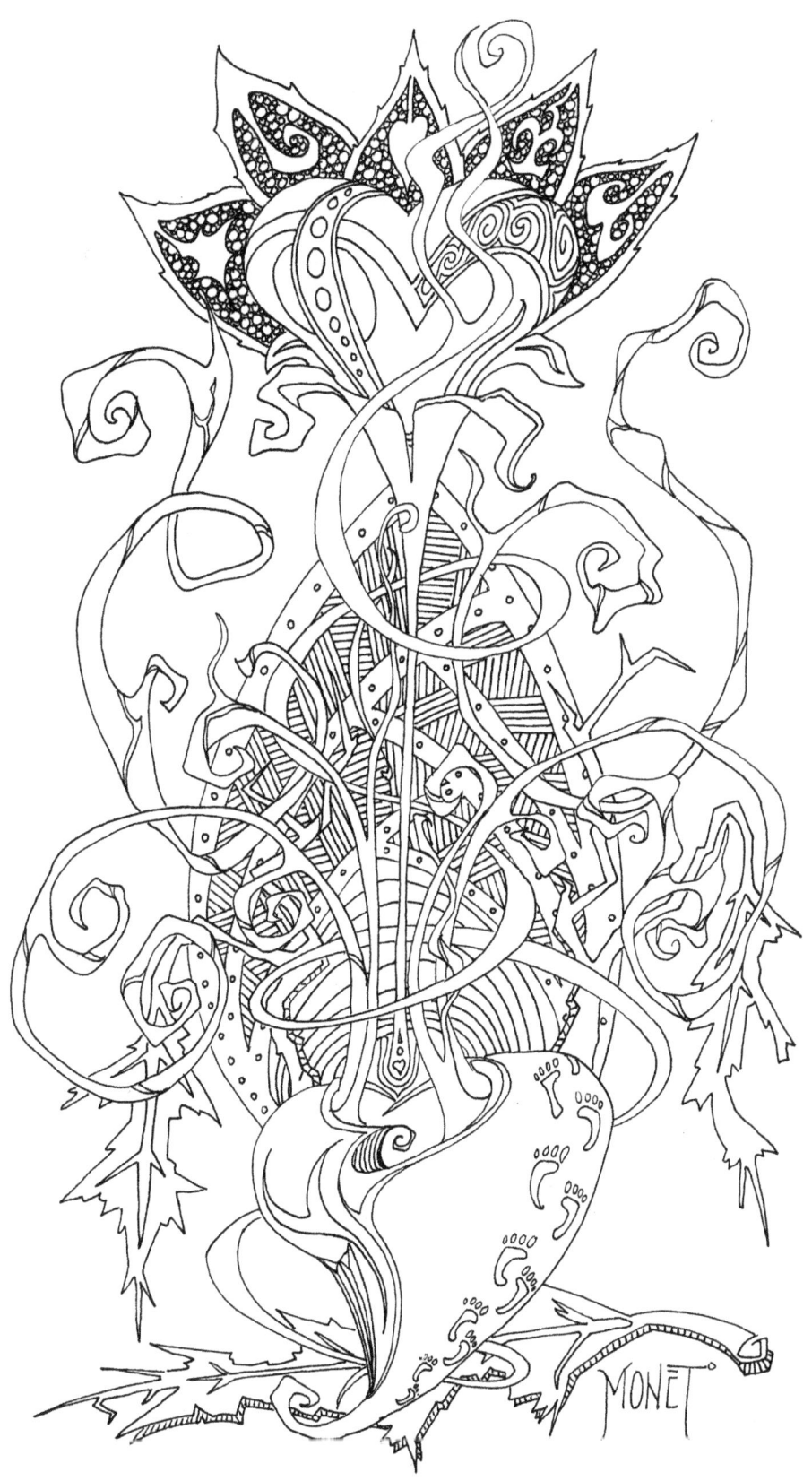

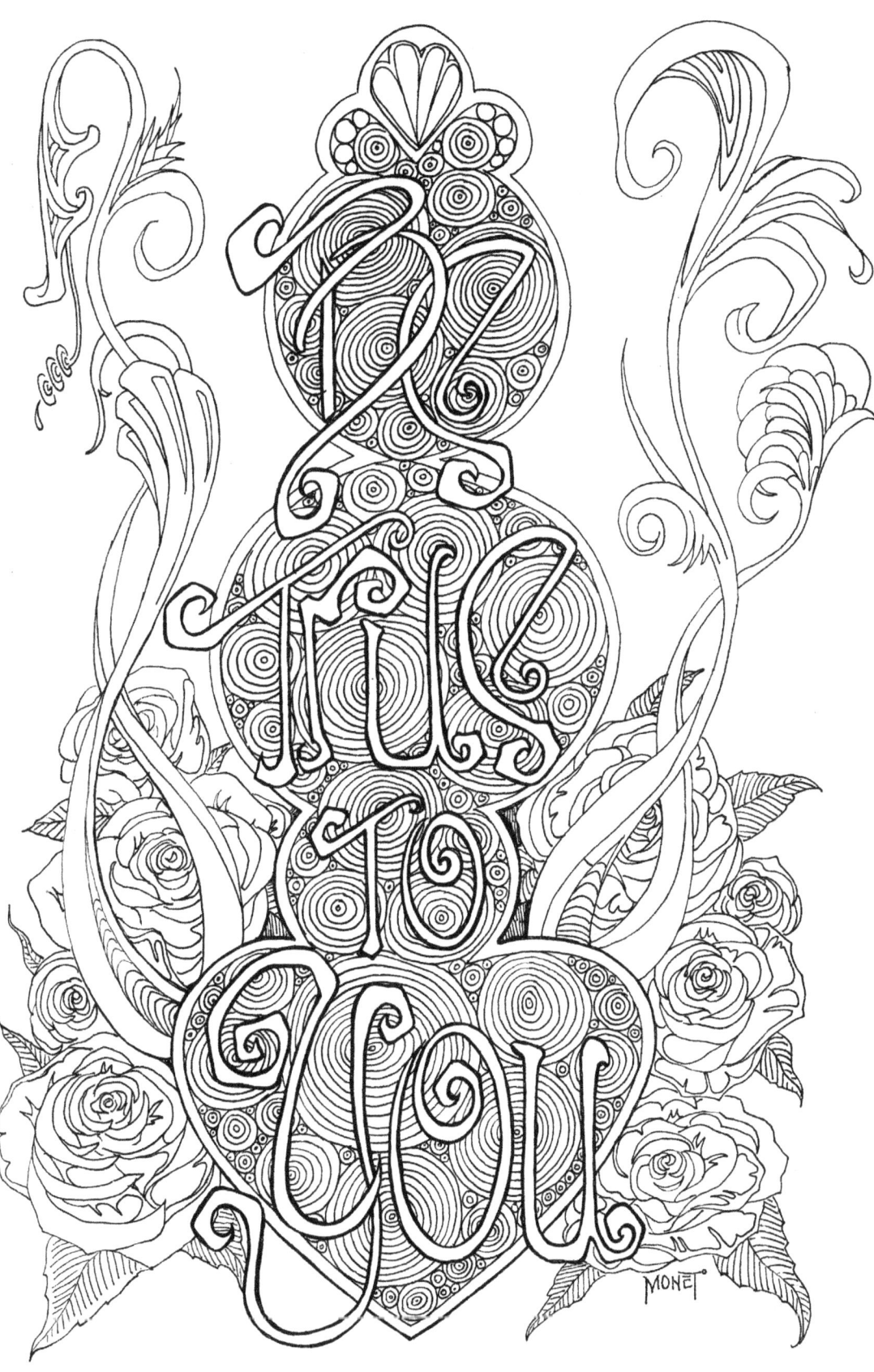

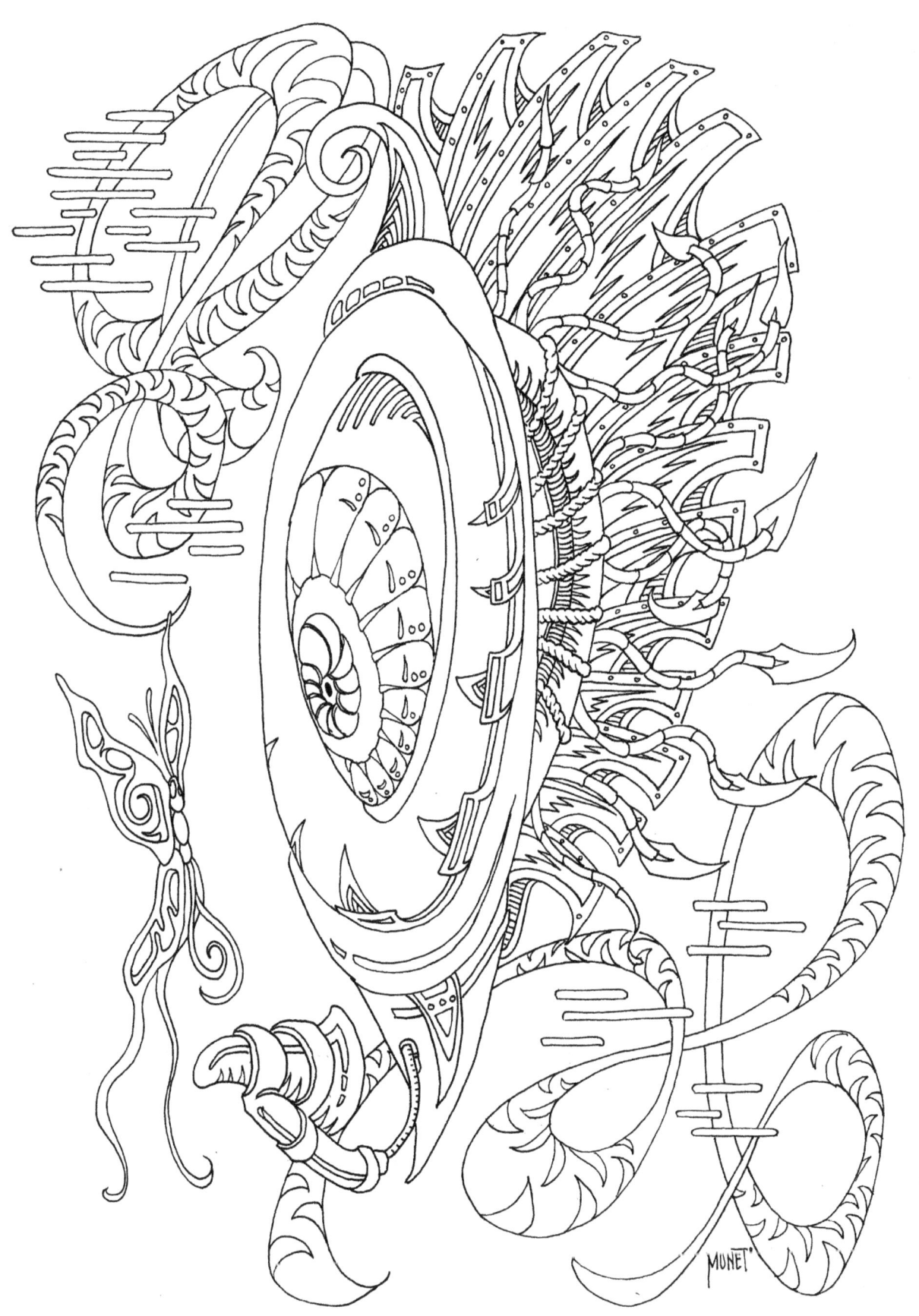

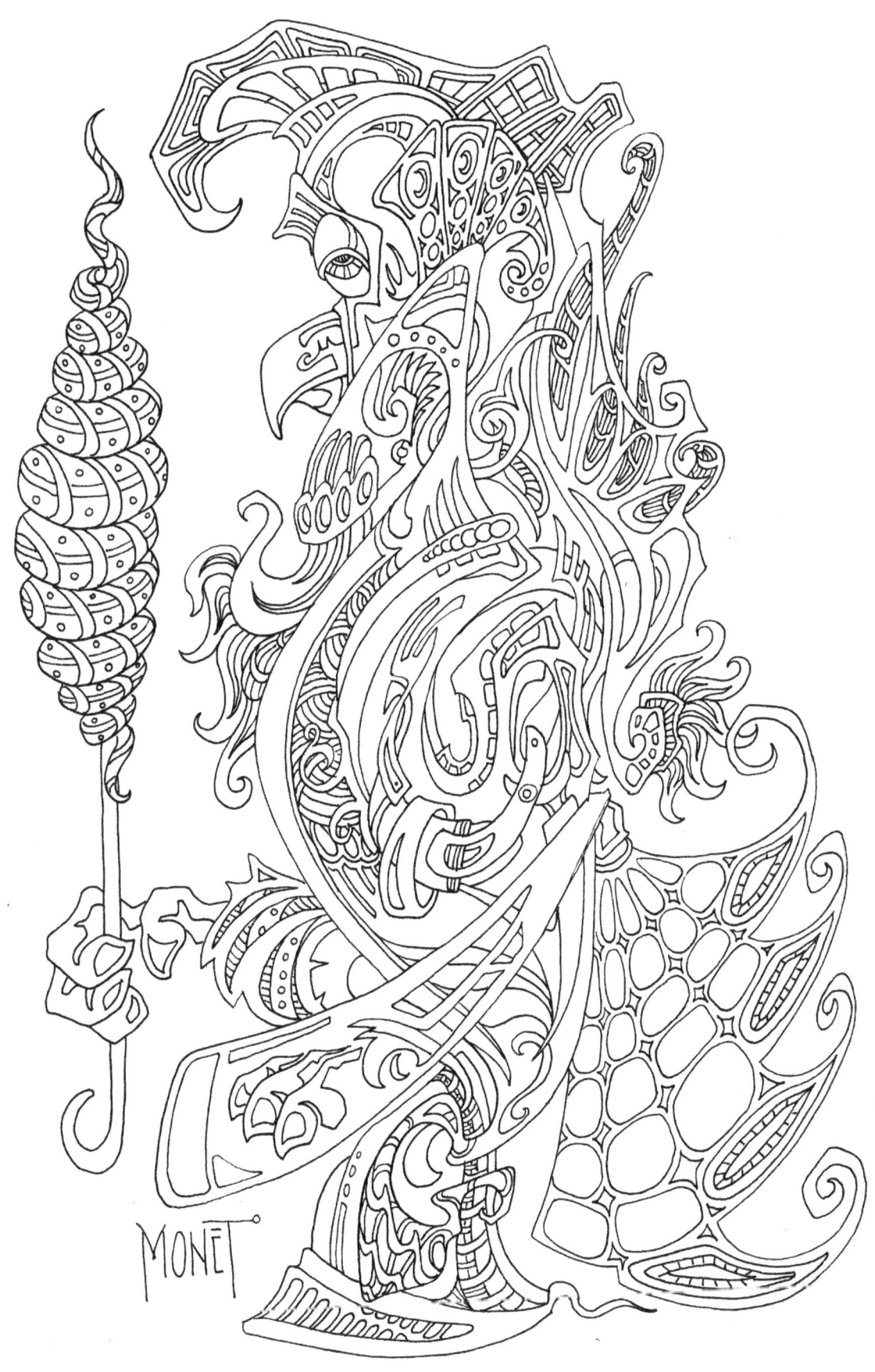

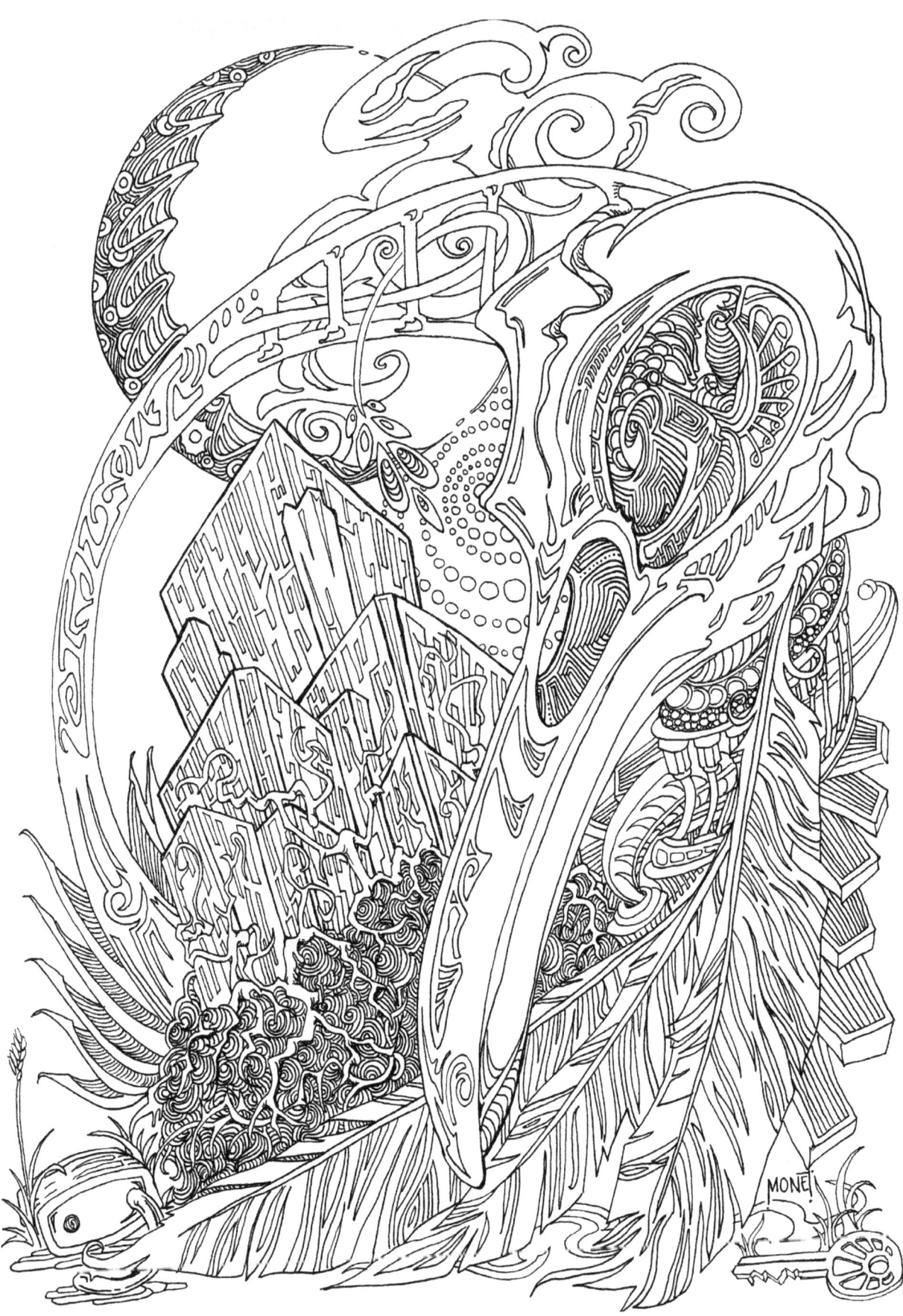

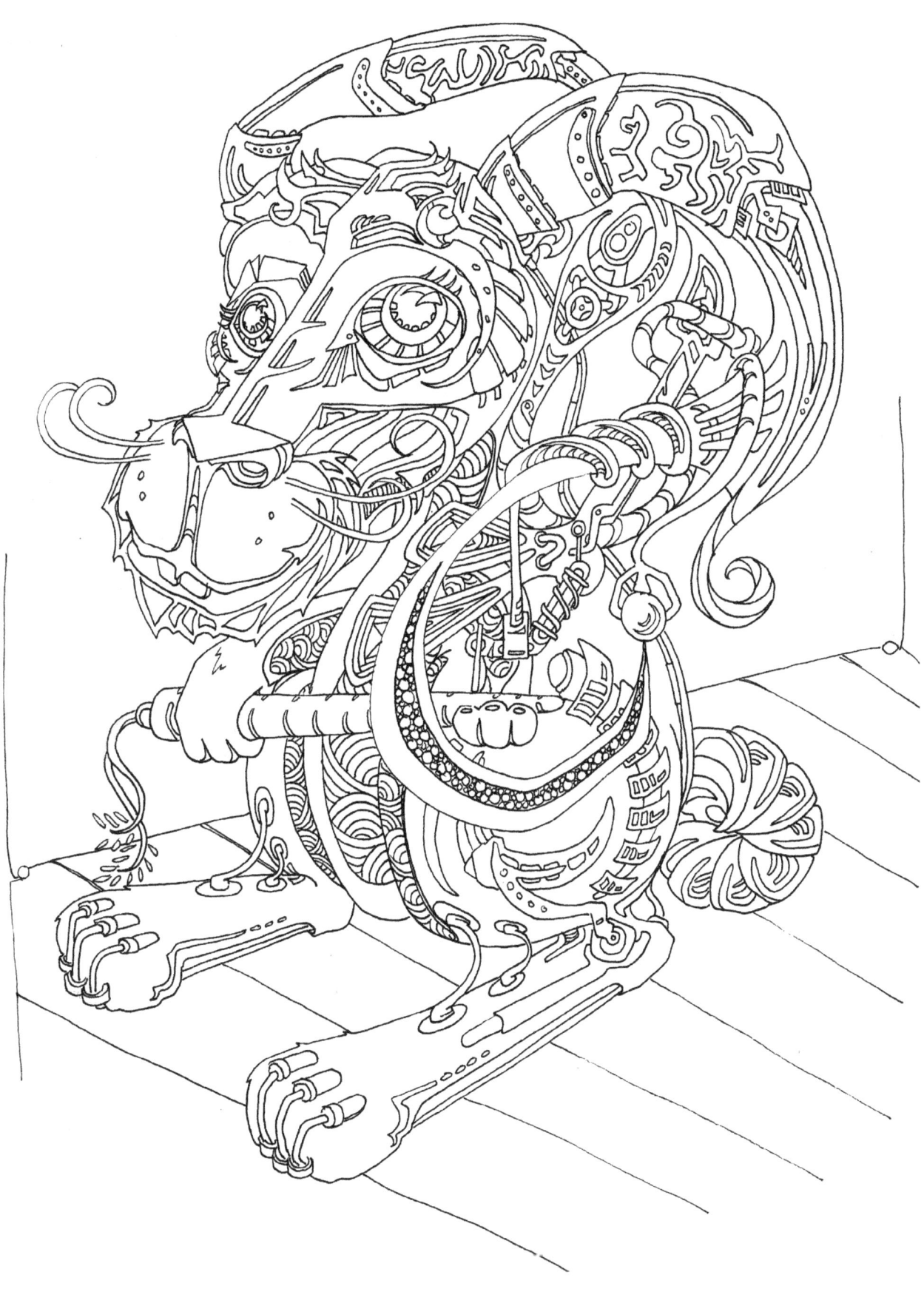

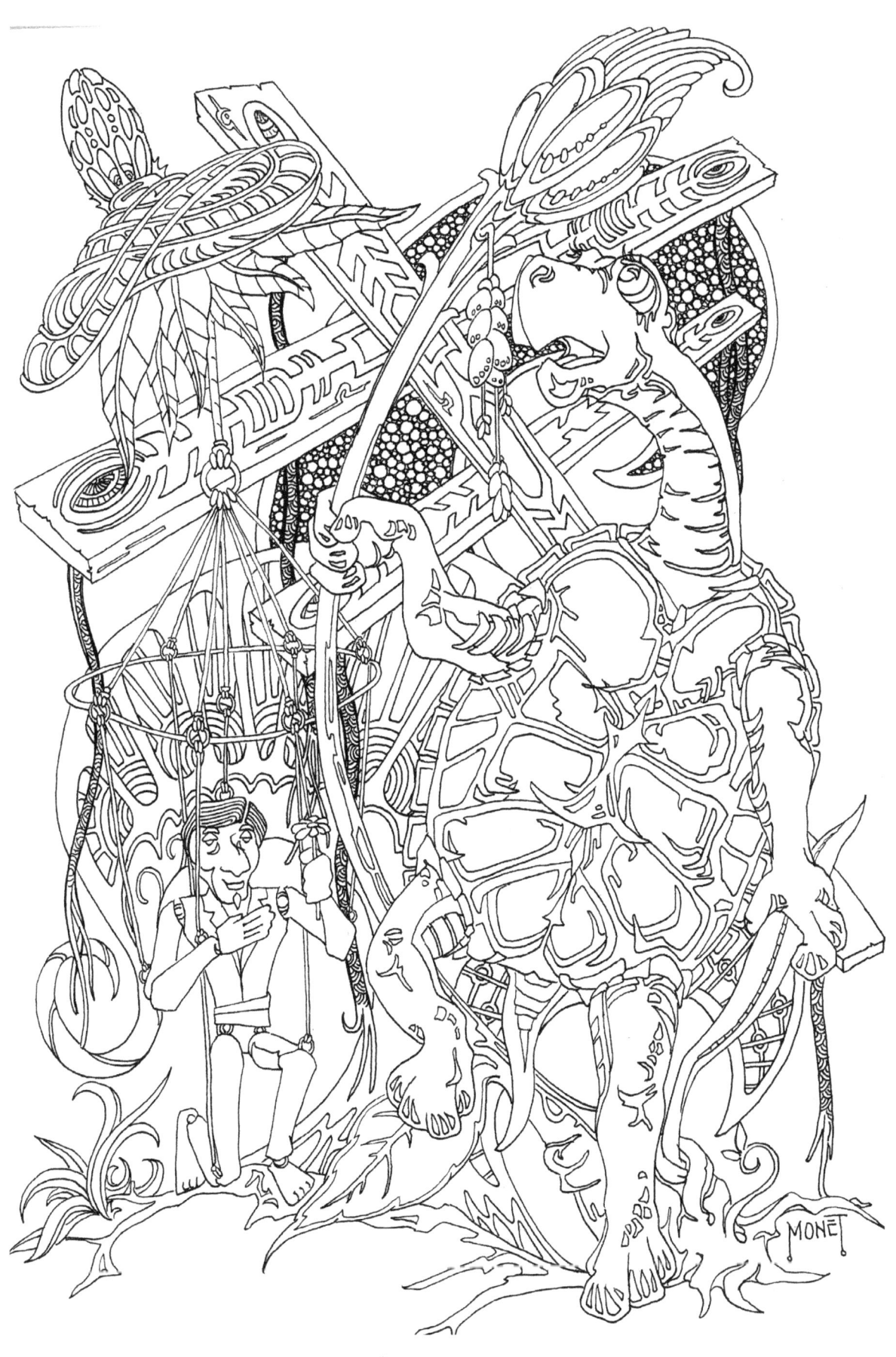

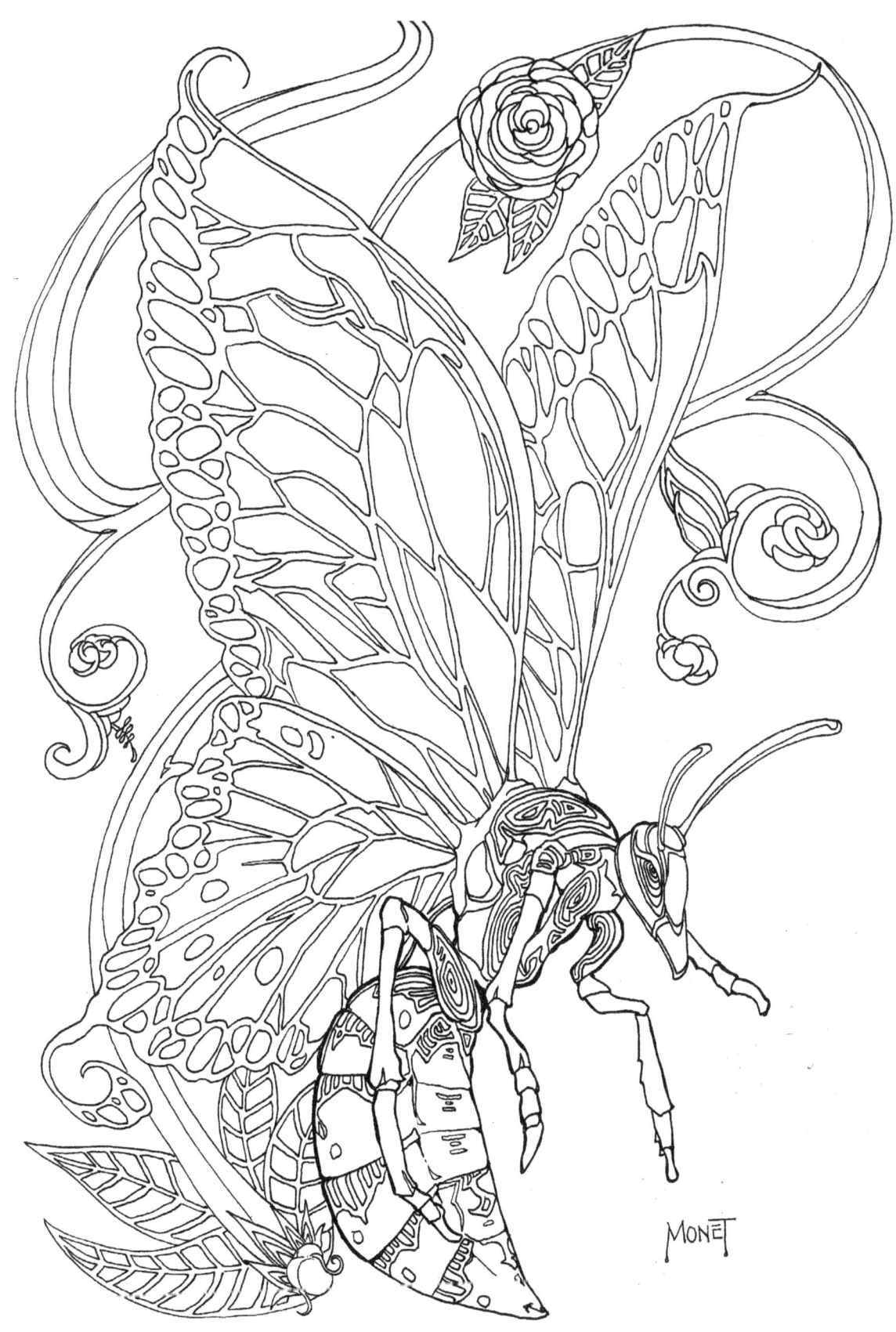

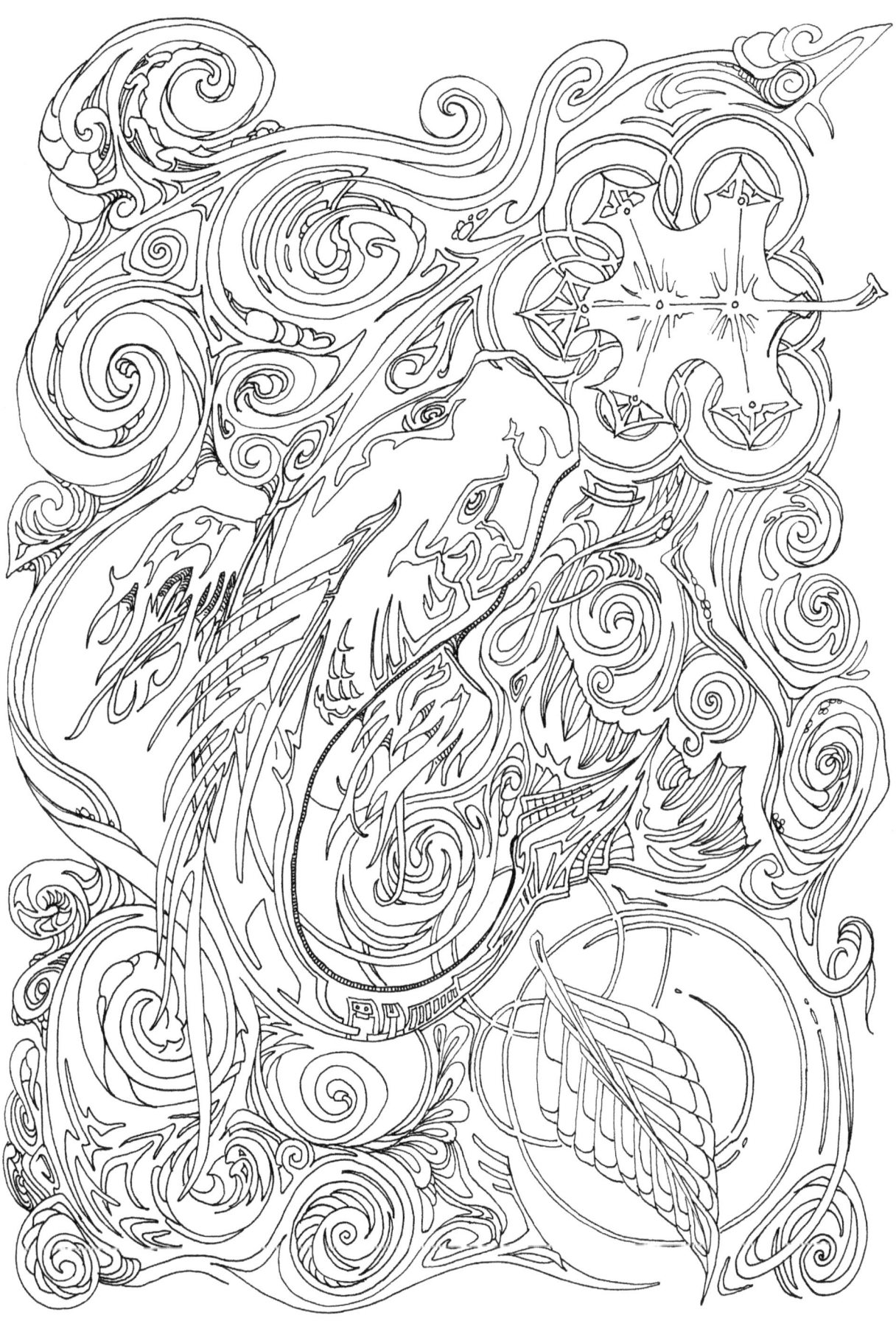

www.ingramcontent.com/pod-product-compliance
Lightning Source LLC
Chambersburg PA
CBHW080524190526
45169CB00008B/3043